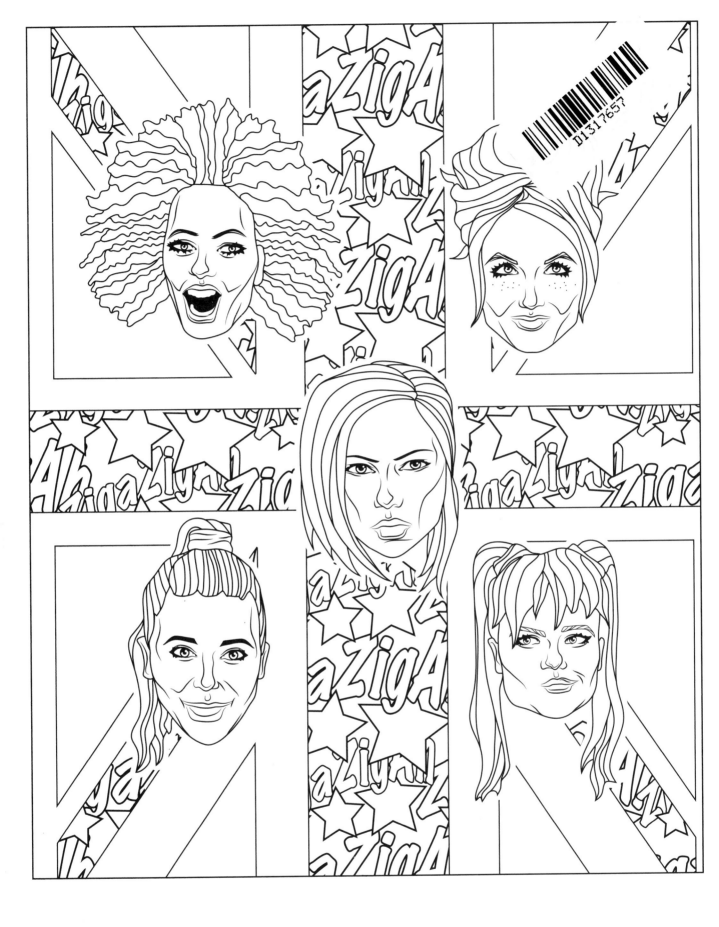

SPICE GIRLS

FUN FACT: Before they were the Spice Girls, the band was originally called Touch — they changed their name to go with the song "Sugar and Spice" after it was written for them!

SPICE GIRLS CONNECT-THE-DOTS!

You wanna really, really, really, wanna draw a zig-a-zag line? Slam your pencil down and wind it all around! Connect the dots in numerical order to bring the Spice Girls' favorite ride to life! Don't be hasty! Give it a try!

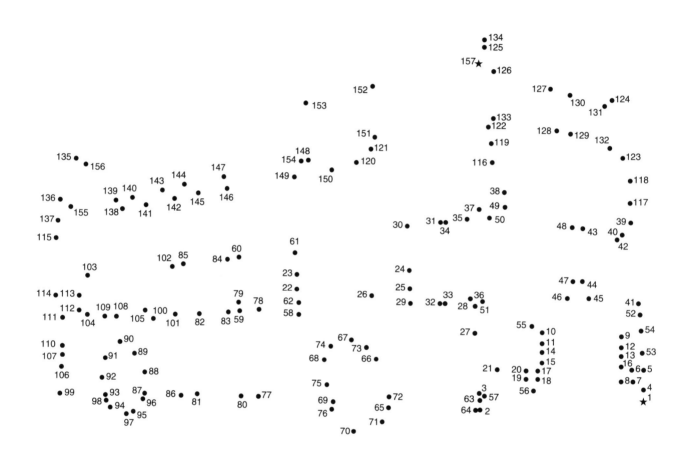

THAT'S ___ SO ___ '90s POP!

A FILL-IN ACTIVITY BOOK

PATRICK SULLIVAN

CLARKSON POTTER/PUBLISHERS
NEW YORK

All rights reserved.
Published in the United States by Clarkson Potter/Publishers,
an imprint of the Crown Publishing Group,
a division of Penguin Random House LLC, New York.
crownpublishing.com
clarksonpotter.com

CLARKSON POTTER is a trademark and POTTER
with colophon is a registered trademark of
Penguin Random House LLC.

Library of Congress Cataloging-in-Publication
Data is available upon request.

ISBN 978-0-451-49954-7

Printed in the United States of America

Cover and book design by Patrick Sullivan
Illustrations by Patrick Sullivan

10 9 8 7 6 5 4 3 2 1

First Edition

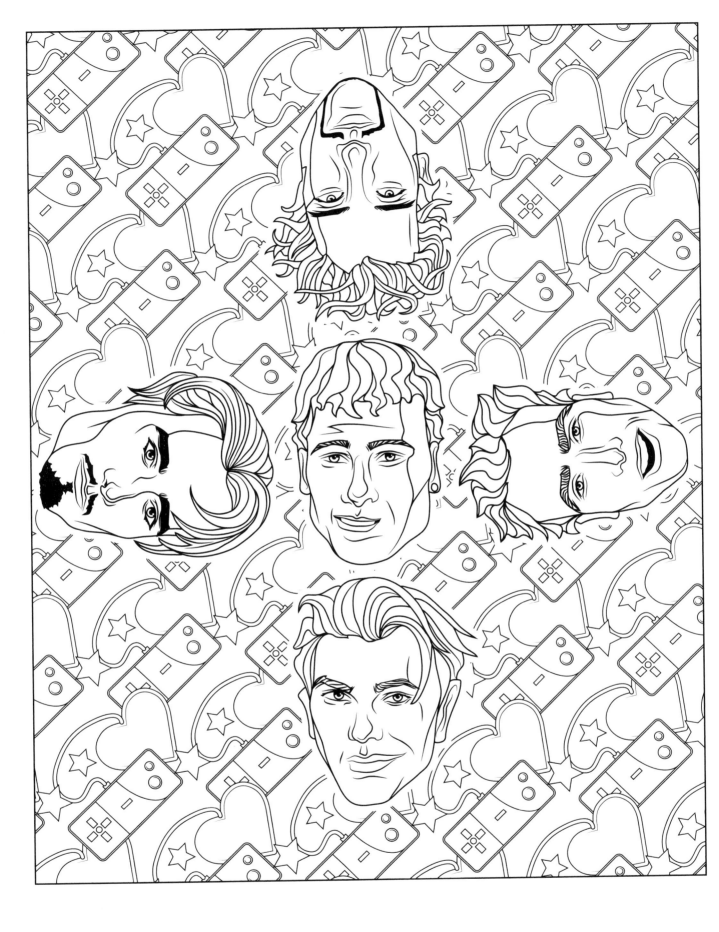

BACKSTREET BOYS

FUN FACT: Watch *Edward Scissorhands* carefully and you might just spot Nick Carter. He is one of the kids playing on the Slip'N Slide in the street!

BACKSTREET BOYS WORD SEARCH!

Quit playin' games and complete this word search instead! All these words you can find, impossible as it may seem. Find all the following words spelled forward, backward, upward, or downward in the word search below!

```
E  W  Q  N  S  K  I  V  U  L  J  C  U  S  E
N  H  D  K  W  I  I  K  A  E  M  T  N  P  K
S  A  C  P  M  U  S  N  I  T  A  D  B  Z  F
M  L  I  A  Y  W  I  E  W  U  A  Q  R  P  K
S  L  G  J  T  G  S  H  U  D  K  L  E  Y  Y
J  E  A  I  I  R  V  V  N  J  M  I  A  U  I
D  P  X  R  X  M  A  C  O  I  T  Z  K  D  W
P  P  O  U  R  G  F  E  L  D  X  P  A  E  G
F  A  R  U  A  I  N  L  H  V  O  Y  B  S  V
E  C  H  X  R  L  E  Z  W  X  C  H  L  I  L
X  A  B  E  U  N  M  I  S  T  A  K  E  R  A
C  B  D  B  N  B  H  K  Q  P  B  H  U  E  S
E  T  D  I  Y  D  O  B  Y  R  E  V  E  P  Y
N  V  U  X  B  C  P  N  W  Z  E  E  X  E  A
R  M  Q  T  D  B  O  Y  D  L  H  H  V  Q  H
```

FIND: ORIGINAL, SEXUAL, EVERYBODY, FIRE, DESIRE, HEARTACHE, MISTAKE, MILLENNIUM, UNBREAKABLE, A CAPPELLA

FUN FACT: Marvel creator Stan Lee made the Backstreet Boys into comic-book stars. He created a comic called *The Backstreet Project,* and only one issue was ever printed.

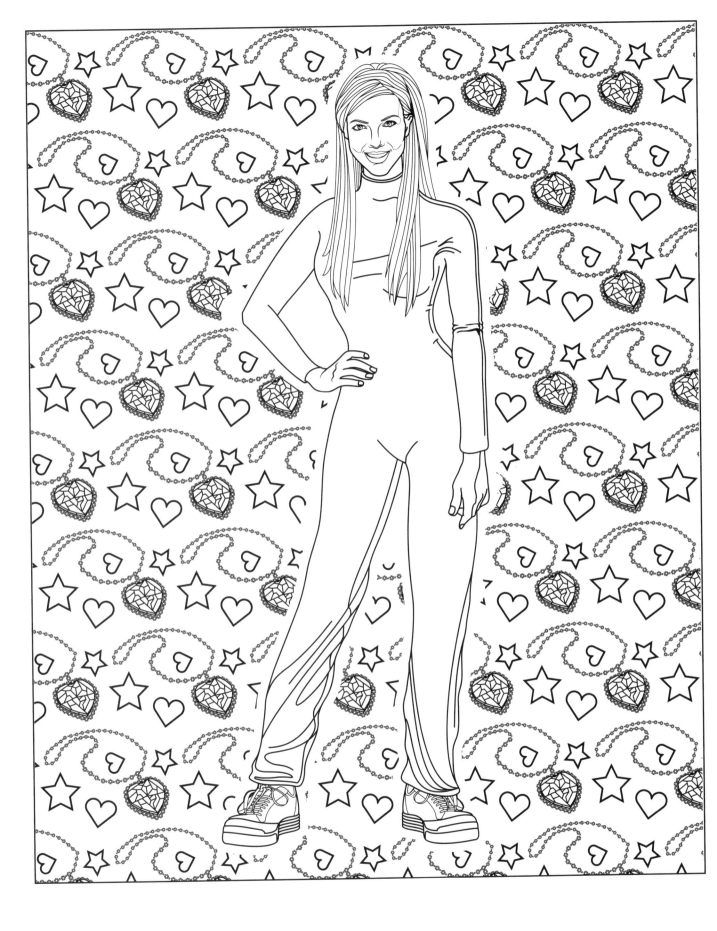

BRITNEY SPEARS

FUN FACT: Britney was the bestselling teenage artist ever, selling more than 37 million albums worldwide before turning twenty in 2001.

BRITNEY SPEARS HEART OF THE OCEAN MAZE

Well baby, find your way down to the center of the maze to get the Heart of the Ocean back for Britney!
Don't get lost in the game. Use a pencil in case you make an "Oops" and have to do it again!

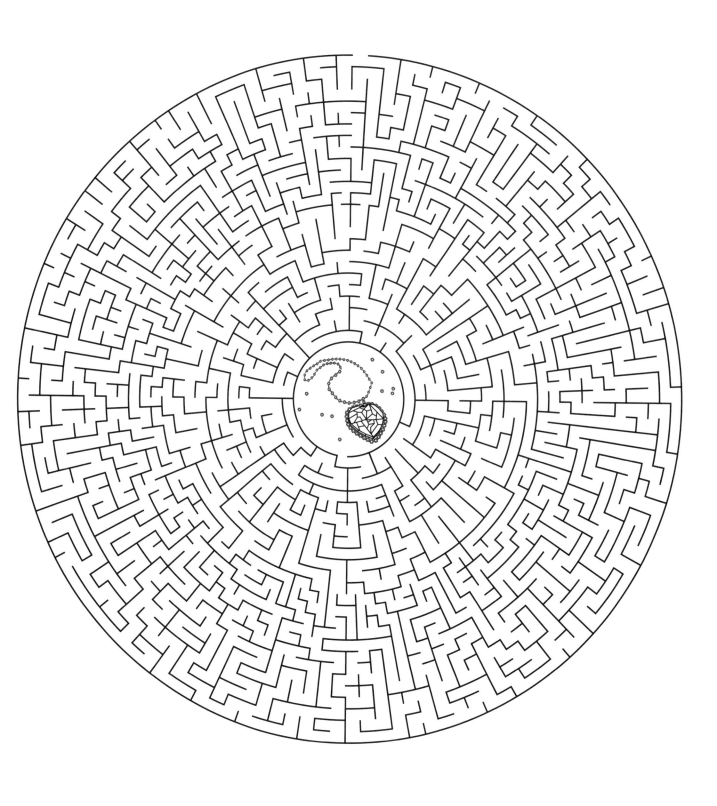

FUN FACT: Britney Spears is an anagram of "Presbyterians."

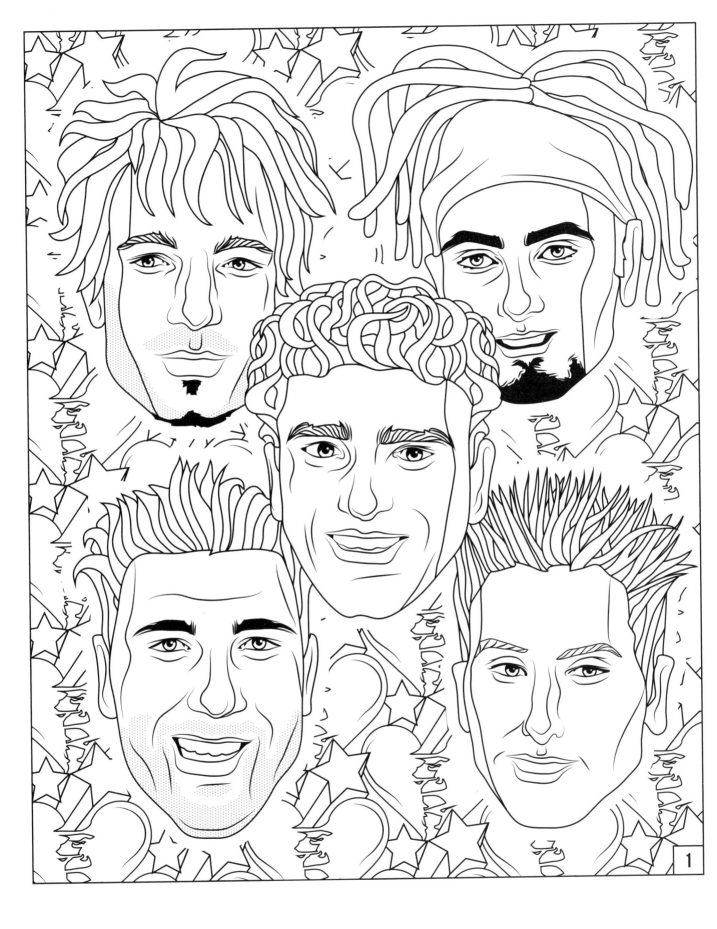

*NSYNC

FUN FACT: *NSYNC is an acronym using the last letter of each of the original members' first names: JustiN, ChriS, JoeY, JasoN, and JC.

*NSYNC WHICH THING IS NOT LIKE THE OTHER?

It might sound crazy but it ain't no lie: these two drawings are not in sync with each other. Say "Bye Bye Bye" to ten things that are different in drawing number 2.

2

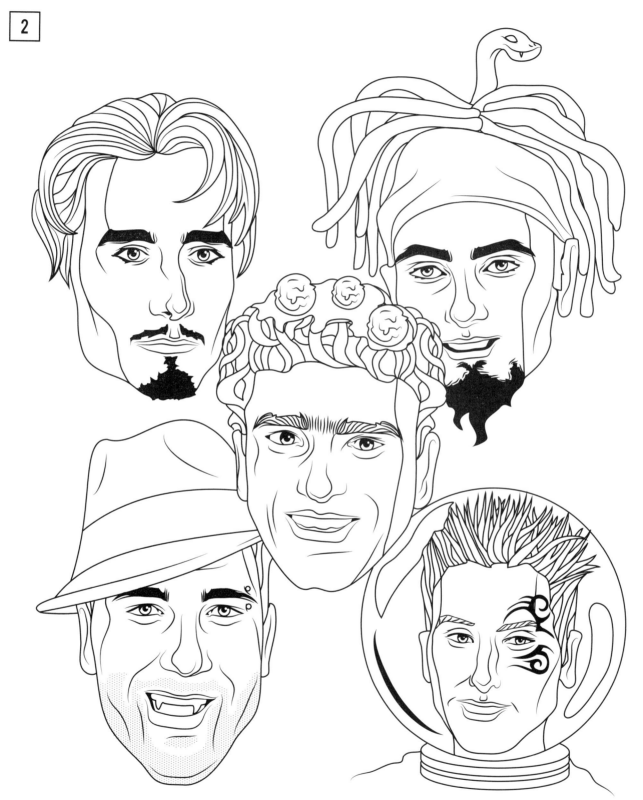

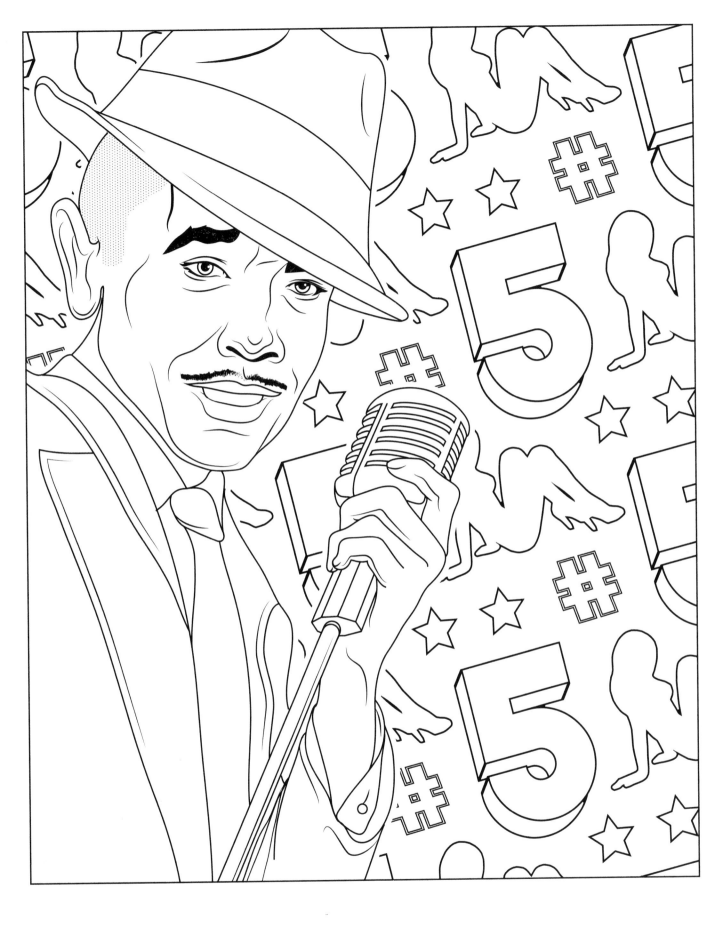

LOU BEGA

FUN FACT: Lou got married at the Graceland Wedding Chapel in Las Vegas!

LOU BEGA WORD SEARCH NUMBER 5!

One, two, three, four, five. How many of the women Lou mentions in "Mambo No. 5" can you find in this word search? If a little bit of Tina is all you see, jump up and down and move it all around to see the rest!

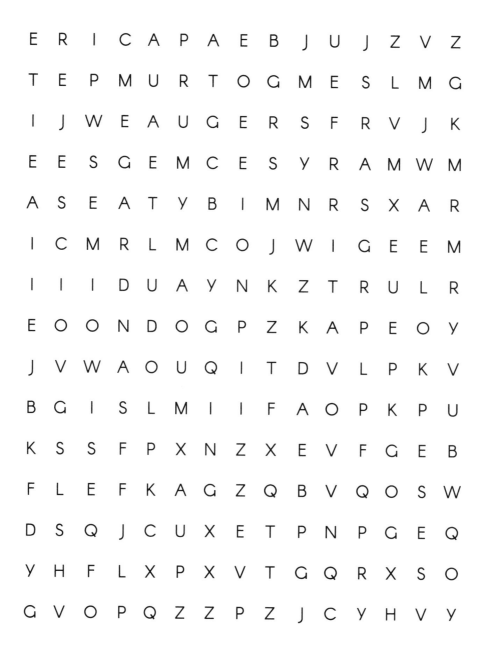

```
E  R  I  C  A  P  A  E  B  J  U  J  Z  V  Z
T  E  P  M  U  R  T  O  G  M  E  S  L  M  G
I  J  W  E  A  U  G  E  R  S  F  R  V  J  K
E  E  S  G  E  M  C  E  S  Y  R  A  M  W  M
A  S  E  A  T  Y  B  I  M  N  R  S  X  A  R
I  C  M  R  L  M  C  O  J  W  I  G  E  E  M
I  I  I  D  U  A  Y  N  K  Z  T  R  U  L  R
E  O  O  N  D  O  G  P  Z  K  A  P  E  O  Y
J  V  W  A  O  U  Q  I  T  D  V  L  P  K  V
B  G  I  S  L  M  I  I  F  A  O  P  K  P  U
K  S  S  F  P  X  N  Z  X  E  V  F  G  E  B
F  L  E  F  K  A  G  Z  Q  B  V  Q  O  S  W
D  S  Q  J  C  U  X  E  T  P  N  P  G  E  Q
Y  H  F  L  X  P  X  V  T  G  Q  R  X  S  O
G  V  O  P  Q  Z  Z  P  Z  J  C  Y  H  V  Y
```

FIND: MONICA, ERICA, RITA, TINA, SANDRA, MARY, JESSICA, TRUMPET, MAMBO, NUMBER, FIVE

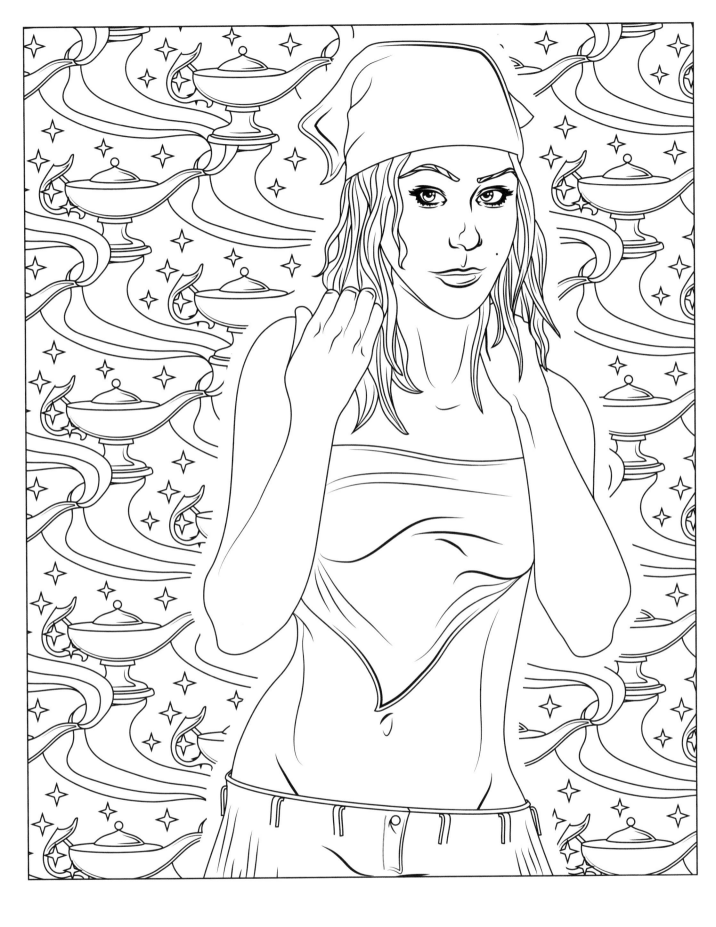

CHRISTINA AGUILERA

FUN FACT: For years, rumors stated that Christina had a rivalry with Britney Spears — these whispers were squashed when they copresented at the 2000 VMAs.

CHRISTINA AGUILERA DRAWING CHALLENGE

There's no genie in this bottle — yet! Come on and let it out. Draw an amazing genie emerging from this bottle and color the whole page your way! Make a big impression!

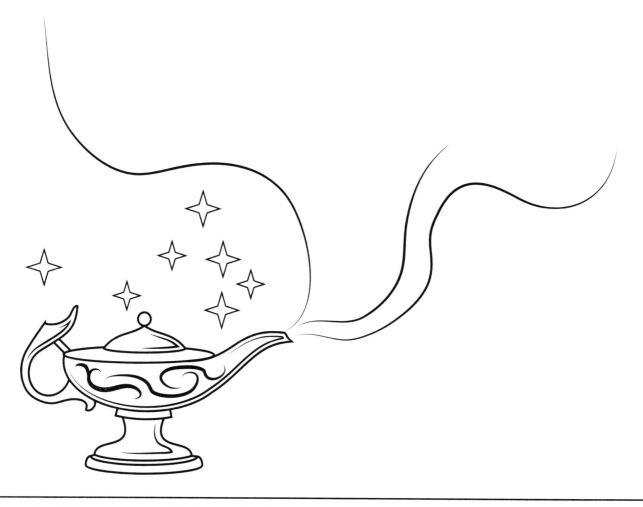

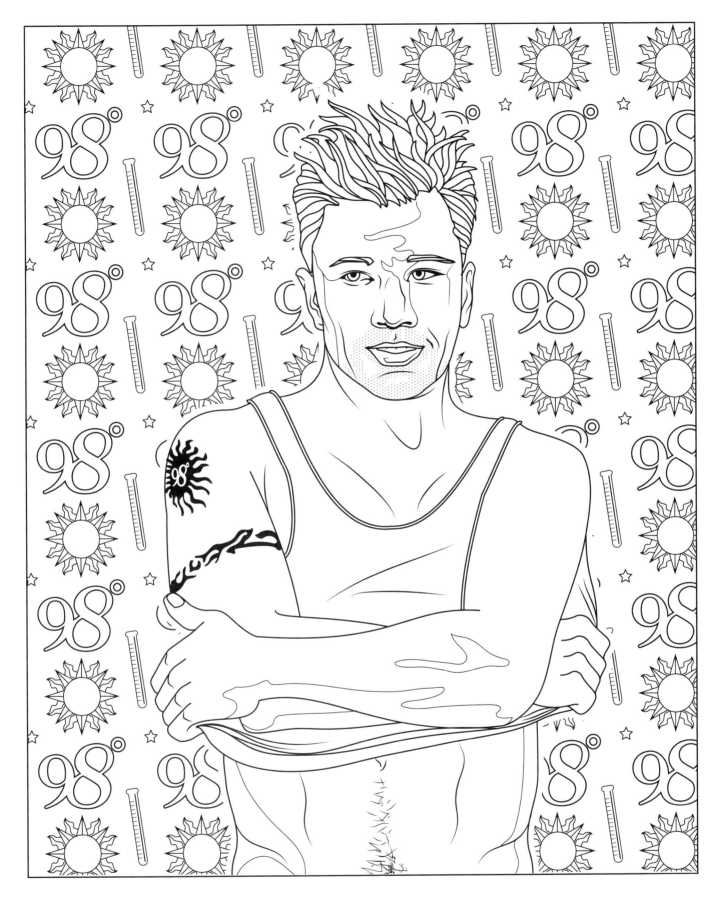

NICK LACHEY

NICK LACHEY 98 DEGREES TRUE OR FALSE QUIZ!

Did you get your degree in pop music? Even if you had 98 degrees you still might not know the answers to all these! Answer true or false for each of the following fun facts and discover which are correct at the bottom of the page.

1. All members of 98 Degrees originated in Ohio.

2. The foursome was assembled by a Motown executive.

3. 98 Degrees was invited to sing live on the radio after sneaking into a Boyz II Men concert.

4. Their debut single landed at number 3 on the Billboard Hot 100.

5. 98 Degrees provided a track to the original motion picture soundtrack to the 1998 animated film *Quest for Camelot*.

6. 98 Degrees provided a track to the original motion picture soundtrack to the 1998 animated film *Mulan*.

7. Stevie Wonder recorded a duet with the group.

8. At least one member of 98 Degrees has run for public office.

9. After 98 Degrees, Jeff Timmons formed a pop act with Chris Kirkpatrick of *NSYNC.

10. Nick Lachey hosted NBC's musical competition show *The Singing Bee*.

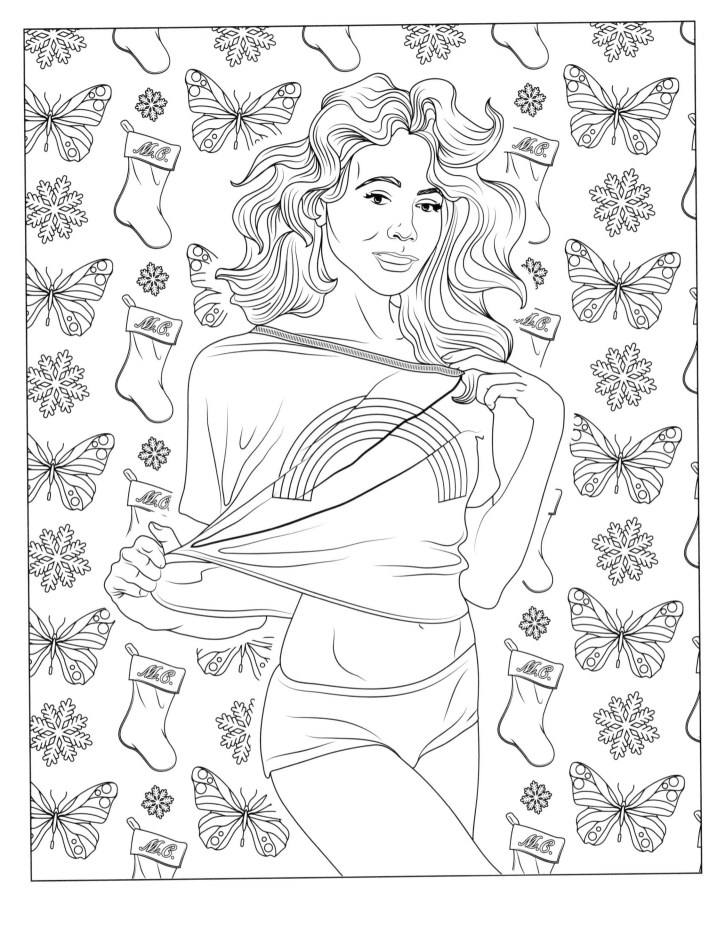

MARIAH CAREY

FUN FACT: Mariah has more number 1 singles than Elvis Presley — only second to the Beatles.

MARIAH CAREY PLAYLIST CROSSWORD PUZZLE

You won't need a hero to come along to complete this puzzle! Mariah is so into you, if you only knew. Prove how into her you are by solving these following clues to complete the crossword puzzle below!

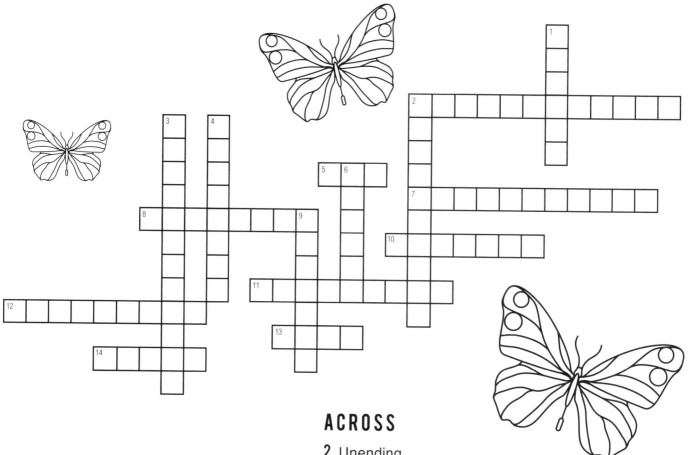

DOWN

1. Ship wrecker.

2. Unavoidably.

3. Poor cholesterol, for one.

4. Inexplicable events.

6. Poem of eight lines.

9. Not necessarily gold.

ACROSS

2. Unending

5. Pinocchio's transformation.

7. Nonstop.

8. Coal depository for the poorly behaved.

10. Genre of dragon books.

11. Caterpillar's makeover.

12. Boxing Day Eve.

13. Clark Kent's night job.

14. Tiny queen's tasty treasure.

ANSWERS: DOWN: 1. CANNON **2.** INEVITABLY **3.** HEARTBREAKER **4.** MIRACLES **6.** OCTAVE **9.** GLITTER **ACROSS: 2.** INDEFINITELY **5.** BOY **7.** INCESSANTLY **8.** STOCKING **10.** FANTASY **11.** BUTTERFLY **12.** CHRISTMAS **13.** HERO **14.** HONEY

FUN FACT: Mariah Carey has a limo for her dog, Jack Russell terrier, Jack, and a five-octave vocal range.

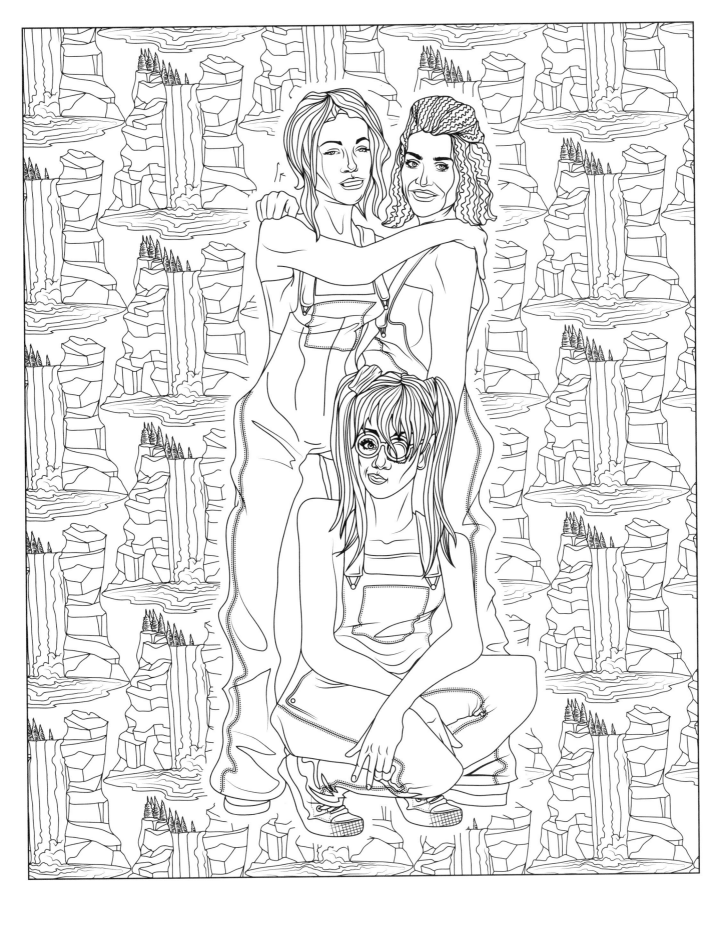

TLC

FUN FACT: TLC's sampling of OutKast and CeeLo Green's work catapulted them onto the national stage.

TLC WORD SEARCH!

A scrub's game may be pretty weak, but this one isn't! Find all the following words spelled forward, backward, upward, or downward in the word search below!

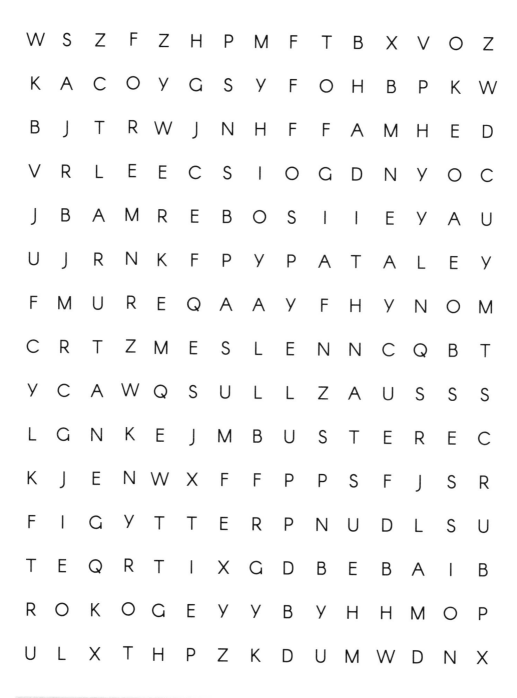

```
W  S  Z  F  Z  H  P  M  F  T  B  X  V  O  Z
K  A  C  O  Y  G  S  Y  F  O  H  B  P  K  W
B  J  T  R  W  J  N  H  F  F  A  M  H  E  D
V  R  L  E  E  C  S  I  O  G  D  N  Y  O  C
J  B  A  M  R  E  B  O  S  I  I  E  Y  A  U
U  J  R  N  K  F  P  Y  P  A  T  A  L  E  Y
F  M  U  R  E  Q  A  A  Y  F  H  Y  N  O  M
C  R  T  Z  M  E  S  L  E  N  N  C  Q  B  T
Y  C  A  W  Q  S  U  L  L  Z  A  U  S  S  S
L  G  N  K  E  J  M  B  U  S  T  E  R  E  C
K  J  E  N  W  X  F  F  P  P  S  F  J  S  R
F  I  G  Y  T  T  E  R  P  N  U  D  L  S  U
T  E  Q  R  T  I  X  G  D  B  E  B  A  I  B
R  O  K  O  G  E  Y  Y  B  Y  H  H  M  O  P
U  L  X  T  H  P  Z  K  D  U  M  W  D  N  X
```

FIND: CHASING, WATERFALLS, NATURAL, OBSESSION, CREEP, SCRUB, BUSTER, PASSENGER, UNPRETTY, LEFT EYE

FUN FACT: TLC held up their label boss, Clive Davis, at gunpoint to get royalties they felt they were owed . . . and it worked.

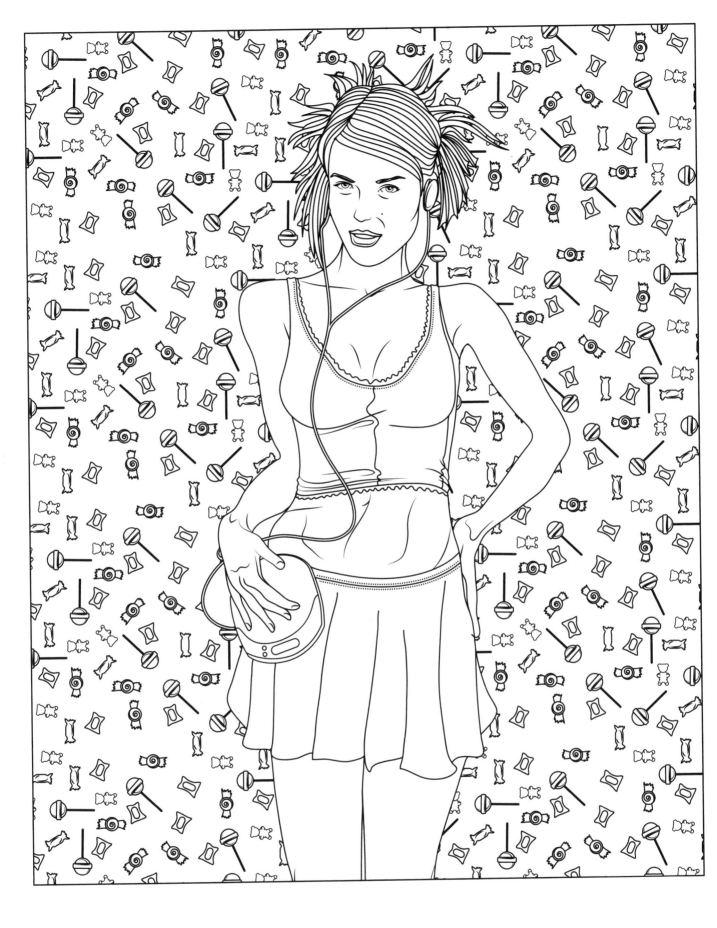

MANDY MOORE

FUN FACT: Mandy Moore was known as the national anthem girl of Orlando when she was just starting out.

MANDY MOORE DRAWING CHALLENGE!

Mandy's missing you like candy! Draw yourself and a friend on an adventure in Mandy's VW Bug!

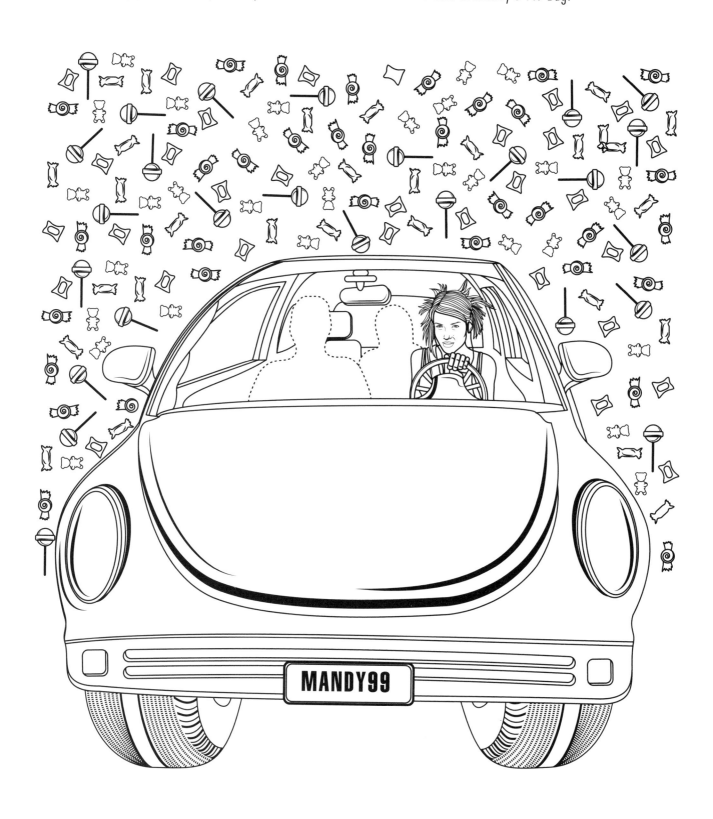

MANDY99

FUN FACT: Mandy Moore is the second cousin of Pink.

ENRIQUE IGLESIAS

ENRIQUE IGLESIAS TWO TRUTHS & A LIE!

Enrique would dance if you asked him to dance. Enrique would run and never look back. Enrique has traveled to Mars. One of those is a lie! Choose the lie out of the sets of fun facts below and discover which are true at the bottom of the page.

ROUND 1 — WHICH IS A LIE?

A. Enrique Iglesias's real last name is Preysler.

B. Enrique has sold 137 million records worldwide.

C. In 2000, Enrique signed a multi-album deal with Universal for under 20 million dollars.

ROUND 2 — WHICH IS A LIE?

A. Despite his sales record, Enrique has never hit number 1 on the Billboard Hot Latin Songs chart.

B. Enrique is the number 1 charting male artist on the Billboard Hot Dance/Electronic Songs chart.

C. Enrique's song "Por Amarte" was featured in the telenovela *Marisol*.

ROUND 3 — WHICH IS A LIE?

A. Enrique Iglesias had the first world tour sponsored by McDonald's.

B. The number 1 hit "Bailamos" was a track off the original motion picture soundtrack to the 1999 action film *Wild Wild West*.

C. Enrique shared his Super Bowl halftime stage with Lenny Kravitz.

ROUND 4 — WHICH IS A LIE?

A. Enrique briefly played on a professional soccer team after his first two albums.

B. Enrique's first time on stage was a childhood production of *Hello, Dolly!*

C. Enrique dedicated his first album to his former nanny, Elvira.

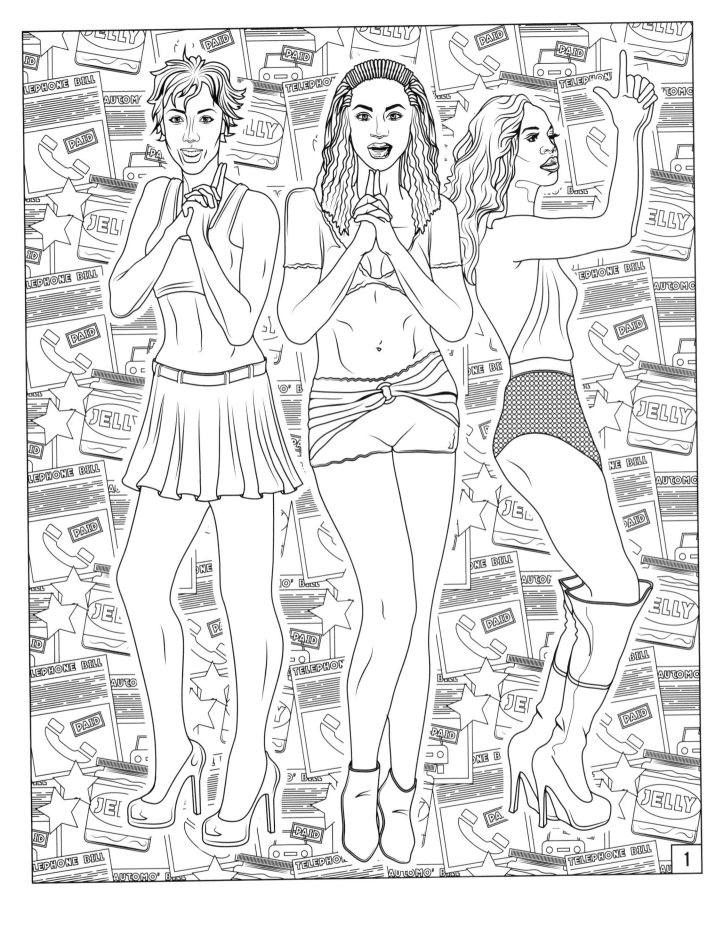

DESTINY'S CHILD

FUN FACT: Destiny's Child, originally called Girl's Tyme, initially wanted to be a rap group.

DESTINY'S CHILD
WHICH THING IS NOT LIKE THE OTHER?

Hopefully this search brings you much success, no stress, and lots of happiness. Use all your wits to locate the ten things that are different in drawing number 2. You're so ready for this jelly.

2

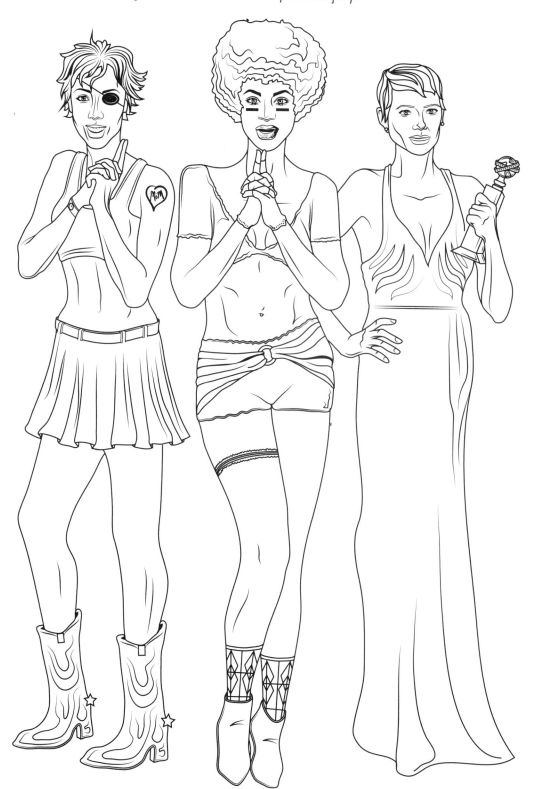

FUN FACT: "Survivor" was actually inspired by a radio DJ making a joke comparing the group and the popular reality series, speculating on who would be the group's longest-lasting member.

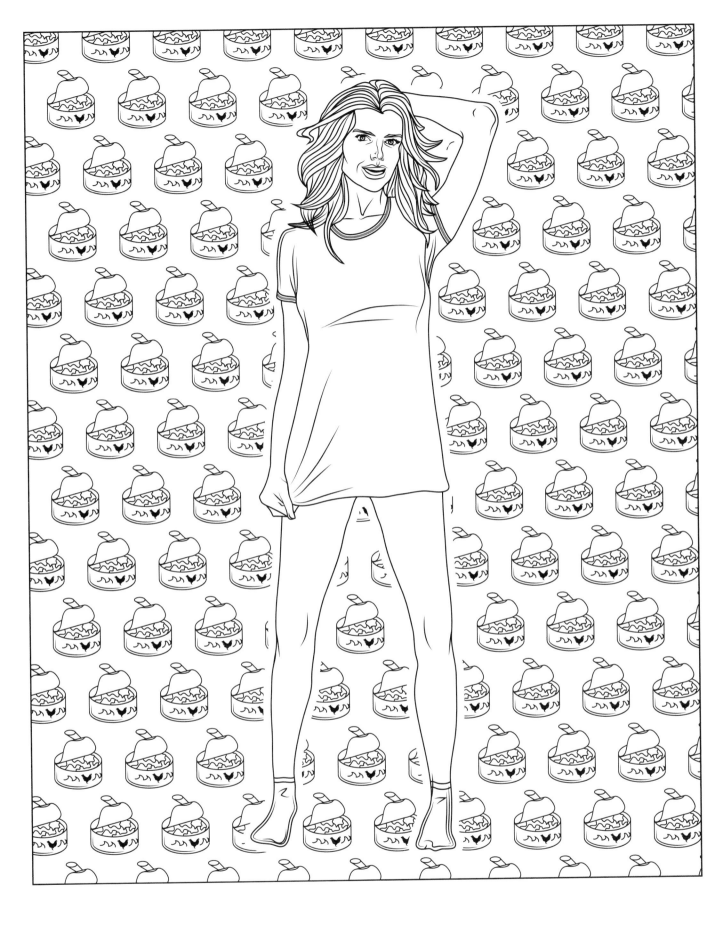

JESSICA SIMPSON

FUN FACT: Jessica Simpson's tears in the video for "I Belong to Me" are real.

JESSICA SIMPSON DRAWING CHALLENGE!

Jessica never feels as beautiful as she does when she has nothing but a T-shirt on. Illustrate a cool design on this blank tee that fashion icon Jessica Simpson would be proud of!

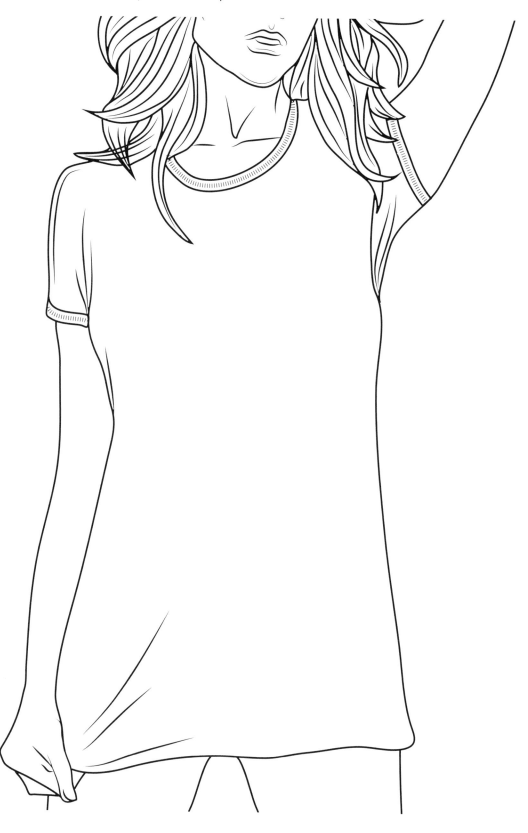

FUN FACT: Jessica Simpson auditioned for the *Mickey Mouse Club*, but when she heard Christina Aguilera sing, she choked.

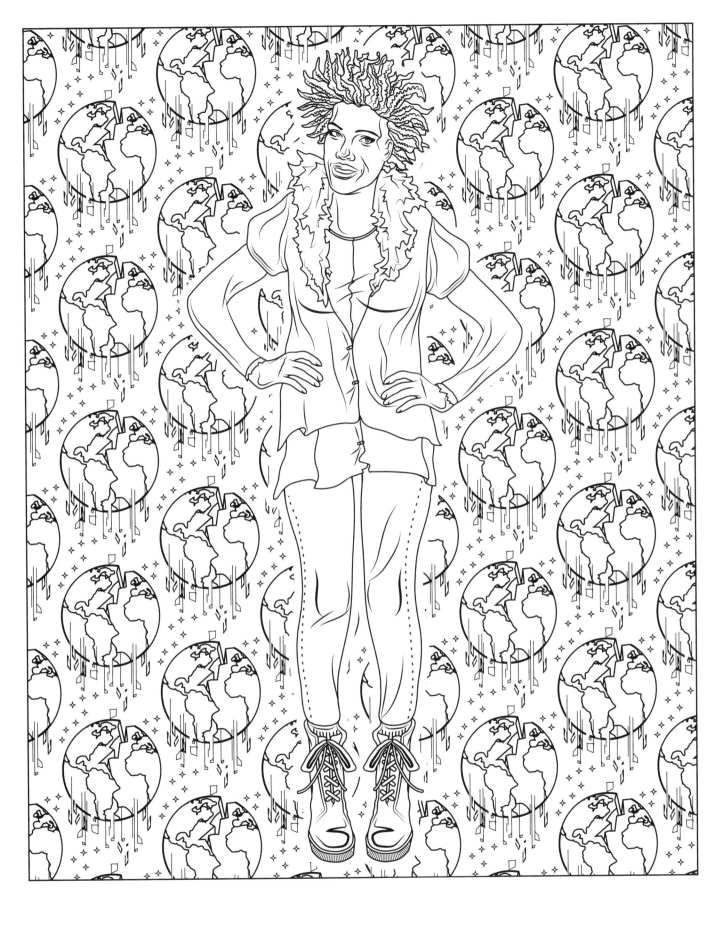

MACY GRAY

↳ **FUN FACT:** Gray sang the theme song for the Nickelodeon animated series *As Told by Ginger*.

MACY GRAY DRAWING CHALLENGE!

Games, changes, and fears. When will they stop? Not yet! Macy Gray's world is crumbling — brighten her day by turning Macy Gray into Macy Rainbow! Fill in each Macy below with the wildest brightest colors you can dream!

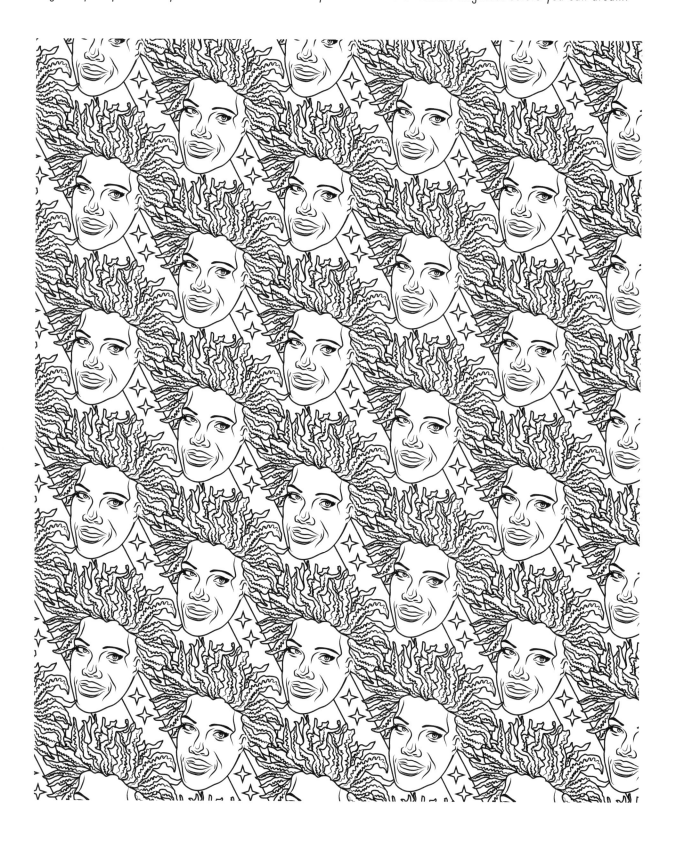

ALANIS MORISSETTE

FUN FACT: Alanis Morissette was actually a pop star in Canada! Her album *Alanis* (released simply under Alanis, rather than Alanis Morissette) went platinum, and she became known as the "Debbie Gibson of Canada" (she was also compared to '80s pop star Tiffany).

ALANIS MORISSETTE WORD SEARCH!

Isn't it ironic? Well, is it? Find out below by searching for each word of this definition of *irony* below!

```
A R E H T O E J S Q H Y B O T
O F P O C G H R B O W R R F H
H Z U Q O Y T A X E C V A N A
T R S O R E X P R E S S U D N
S O M E T H I N G G L Z M J L
K I R D O K D D Q Y M K B M Y
J H J I X A O T B Z G P C X L
I S I S W Y M Q A S G O Y L L
O O U C E Y Y E V H N K F I A
O P P O S I T E A V T K H T I
S D R O W N B K E N T W X E C
B P E Q Q A O Y S Y I R Z R E
I T S H L M V N Q E N N Y A P
T J G L Z V S X S L E U G L S
J H A N D I L U U F E O M Y E
```

FIND: THE USE OF WORDS TO EXPRESS SOMETHING OTHER THAN AND ESPECIALLY THE OPPOSITE OF THE LITERAL MEANING

FUN FACT: In real life, "You Oughta Know" is about Dave Coulier, the actor who played Joey Gladstone (Uncle Joey) on *Full House*.

AARON CARTER

FUN FACT: Aaron Carter performed as an opening act for Britney Spears and the Backstreet Boys.

AARON CARTER CONNECT-THE-DOTS!

So check it out! It's like boom, you draw a few loops. Like, slam! Now you're drawing with a plan. I swear I'm telling you the facts, 'cause that's how you'll draw Shaq! Connect the dots in numerical order to bring Aaron and Shaq's iconic b-ball match to life!

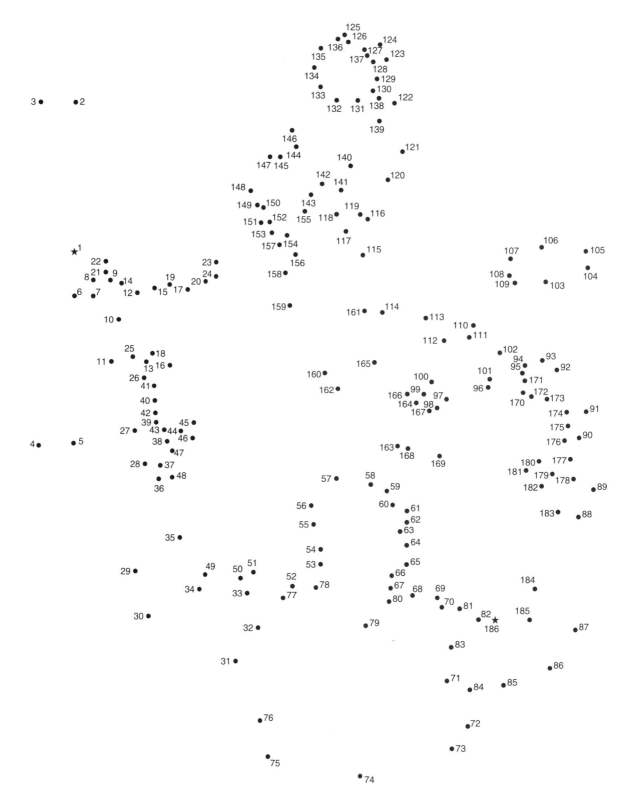

FUN FACT: Aaron Carter began dating actress Lindsay Lohan while he was still dating actress Hilary Duff.

LIL' KIM

LIL' KIM TWO TRUTHS & A LIE!

Lil' Kim has money in her pockets. Lil' Kim has pictures of you in a heart-shaped locket. Lil' Kim has every episode of *Charles in Charge* on DVD. One of those is a lie! Choose the lie out of the sets of fun facts below and discover which are true at the bottom of the page.

ROUND 1 — WHICH IS A LIE?

A. Kim has been referred to as Queen Bee.

B. Kim has been referred to as Ms. Top Dog.

C. Kim has been referred to as Ms. GOAT.

ROUND 2 — WHICH IS A LIE?

A. Kim attended the same high school as Foxy Brown.

B. Kim attended the same high school as Nas.

C. Kim attended the same high school as Damian Marley.

ROUND 3 — WHICH IS A LIE?

A. Kim recorded the track "Not Tonight" with Missy Elliott and Angie Martinez.

B. Kim recorded the track "Not Tonight" with Trina and Mary J. Blige.

C. Kim recorded the track "Not Tonight" with Da Brat and Lisa "Left Eye" Lopes.

ROUND 4 — WHICH IS A LIE?

A. Kim recorded a track for the WWE.

B. Kim recorded a track for *Bad Girls Club*.

C. Kim pretended to go into labor on a hidden-camera prank show.

ANSWERS: 1. C is a lie. 2. C is a lie. 3. B is a lie. 4. B is a lie.

P!NK

P!NK TRUE OR FALSE QUIZ!

You make me sick! False! I want you and I'm hatin' it. True! Get this party started and answer true or false for each of the following fun facts, then discover which are correct at the bottom of the page.

1. Pink was originally in the girl group Choice.
2. "Pink" was originally a nickname used to insult her in high school.
3. Pink received her first Grammy Award for "Just Like a Pill."
4. Pink's mother was a songwriter.
5. Pink suffers from asthma.
6. In high school Pink's band Middleground won the battle of the bands.
7. Pink's real name is Alison Lesser.
8. Before she was Pink, she contributed vocals to a song on the soundtrack to the 1996 film *Kazaam*.
9. Pink was asked to record a single for the 2006 World Cup.
10. Pink was part of the cast of *Charlie's Angels: Full Throttle*.

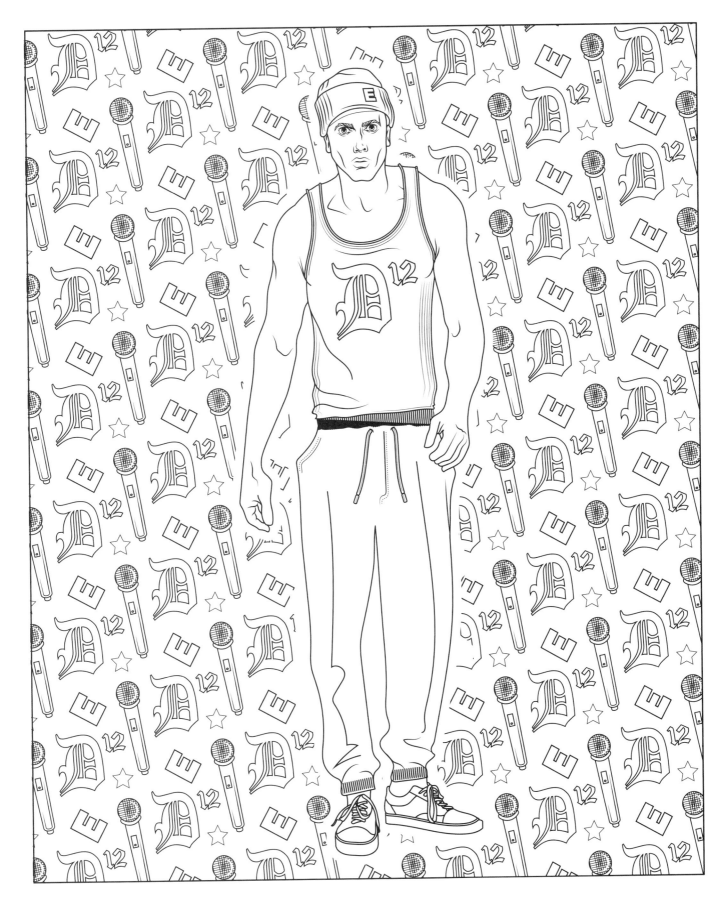

EMINEM

FUN FACT: If you want to be signed to Shady Records, you have to battle Eminem.

EMINEM FILL-IN-THE-BLANK HAIKU

Look if you had one shot, one opportunity to fill in the blanks below and write your own haikus about Eminem utilizing the challenge words provided, would you capture it?

EXAMPLE

USE: SLIM

HI, HIS NAME IS WHAT?
(5 SYLLABLES)

THE REAL SLIM SHADY, HE SAYS.
(7 SYLLABLES)

BUT WILL HE STAND UP?
(5 SYLLABLES)

ROUND 1

USE: HAILIE

(5 SYLLABLES)

(7 SYLLABLES)

(5 SYLLABLES)

ROUND 2

USE: RABBIT

(5 SYLLABLES)

(7 SYLLABLES)

(5 SYLLABLES)

ROUND 3

USE: SPAGHETTI

(5 SYLLABLES)

(7 SYLLABLES)

(5 SYLLABLES)

FUN FACT: The only book Eminem has ever read in full is LL Cool J's _I Make My Own Rules._

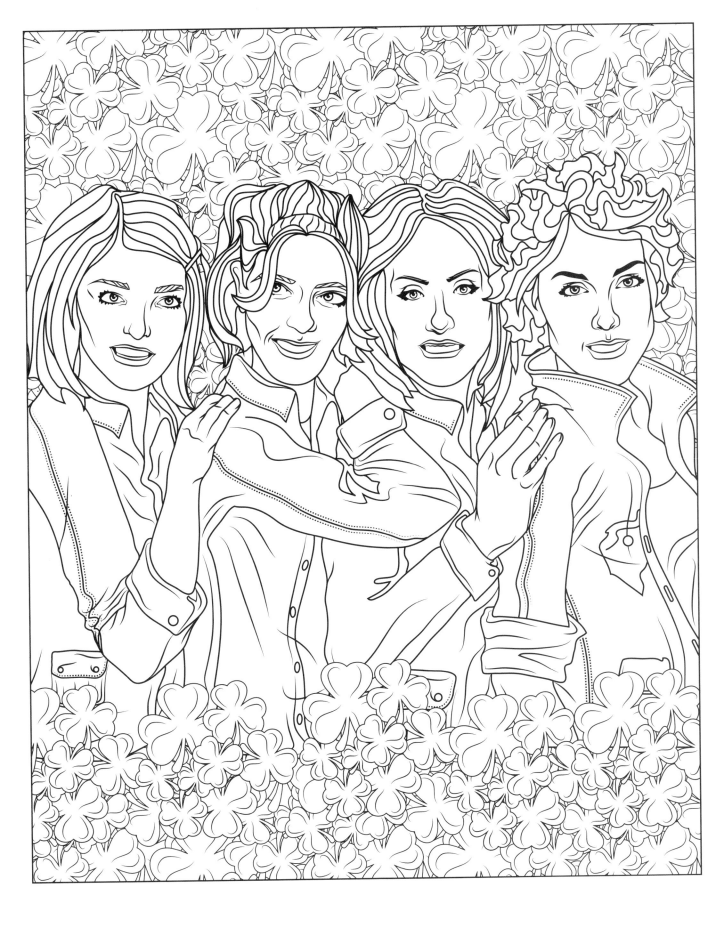

B*WITCHED

B*WITCHED THAT'S SO '90S POP QUIZ!

Which '90s girl group are you? Answer the questions below in the That's So '90s Pop Quiz to find out if you are TLC, Spice Girls, or B*Witched!

QUESTION 1

HOW WOULD YOU DESCRIBE YOUR FAMILY?

A. People mention you resemble your father.

B. Your mother looks out her window when she feels lonely.

C. Friendship is like family for you, it lasts forever.

QUESTION 2

HOW WOULD YOU DESCRIBE YOUR DANCE STYLE?

A. You can get down to a mean fiddle solo.

B. You're often told you're moving too fast.

C. You slide onto every dance floor you see.

QUESTION 3

HOW WOULD YOU DESCRIBE YOUR LOVE LIFE?

A. Your love is very quid pro quo.

B. You demand new loves get along with your friends.

C. You're a creep!

QUESTION 4

WHAT IS YOUR PERSONAL MOTTO?

A. That's life!

B. Girl power!

C. Stay in your lane.

QUESTION 5

HOW WOULD YOU DESCRIBE YOUR STYLE?

A. Adidas and denim.

B. Platforms and miniskirts.

C. Converse and condoms.

ANSWERS:

Mostly As: You're B*Witched! You may fly a little under the radar, but when you huff and you puff, you blow everyone away. You're an acquired taste, but some peoples' favorite person ever. Also, maybe you have an Irish accent!

Mostly Bs: You're the Spice Girls! You are having a good time and spice up everyone's life. You're a girl's girl, but you know how tough that makes you!

Mostly Cs: You're TLC! You're crazy, you're sexy, you're cool. You get into trouble sometimes, but you're socially conscious and you have a style no one can beat.

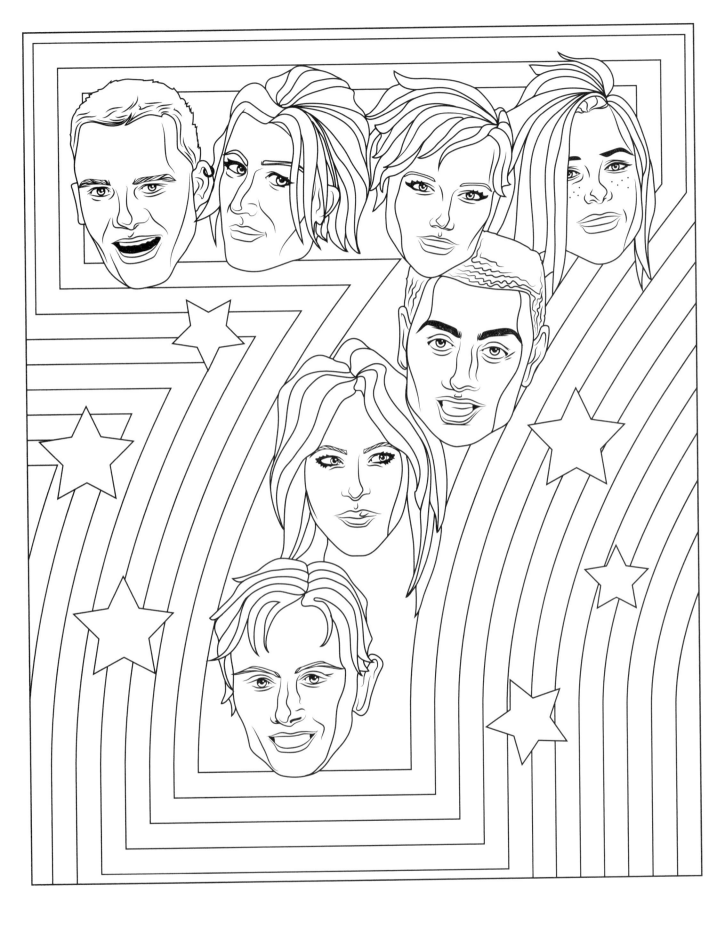

S CLUB 7

FUN FACT: S Club 7 was put together by former Spice Girls manager Simon Fuller. He originally wanted to call the group Spice Club 7, but the label said that it was too blatant an attack.

S CLUB 7 HANGMAN!

Don't stop. Never give up. Have a friend guess the S Club 7 lyrics provided at the bottom of the page to fill in the blanks of these hangman quizzes, letter by letter. For every wrong guess, draw a head, then a body, and then two arms. If you get to both legs, you're out! Show the world what you have got!

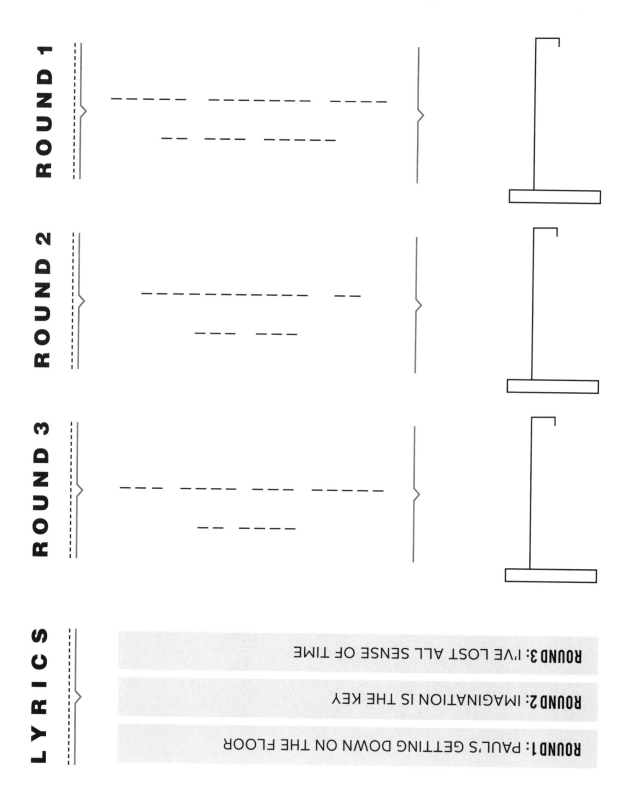

ROUND 1

_ _ _ _ _ _ _ _ _ _ _ _ _ _ _

_ _ _ _ _ _ _ _ _ _

ROUND 2

_ _ _ _ _ _ _ _ _ _ _

_ _ _ _ _ _

ROUND 3

_ _ _ _ _ _ _ _ _ _ _ _ _ _ _

_ _ _ _ _ _

LYRICS

ROUND 3: I'VE LOST ALL SENSE OF TIME

ROUND 2: IMAGINATION IS THE KEY

ROUND 1: PAUL'S GETTING DOWN ON THE FLOOR

CARSON DALY CUT-OUT MASK!

Miss *TRL*? Who doesn't? Now you don't have to. After coloring it in, cut out this Carson Daly mask to host your own countdown! (Nail polish not included.)

FUN FACT: Carson Daly learned his two-year romance with girlfriend Jennifer Love Hewitt was over when he heard it on the radio in 1999.

CARSON DALY HOST YOUR OWN COUNTDOWN

Use this back-of-the-mask page to rank the top songs you'd totally request live!

TOP TEN SONGS OF THE '90S!

10. _____

9. _____

8. _____

7. _____

6. _____

5. _____

4. _____

3. _____

2. _____

1. _____

FUN FACT: Carson Daly was O. J. Simpson's caddy and played against Tiger Woods in the American Junior Golf Association.

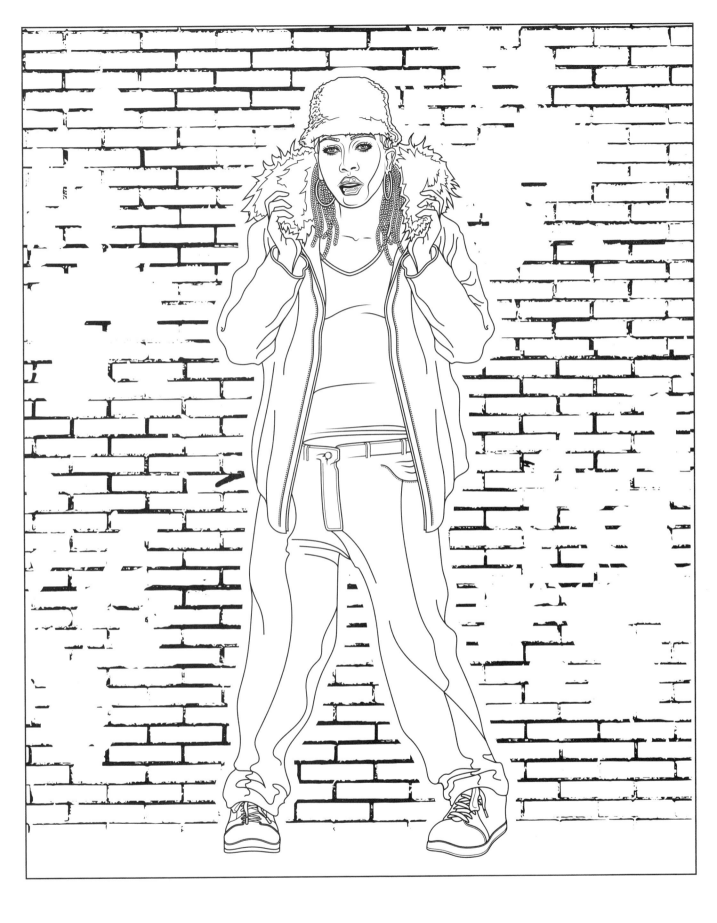

MISSY ELLIOTT

FUN FACT: Missy Elliott is the only female rapper whose six albums have all been platinum certified by the Recording Industry Association of America.

MISSY ELLIOTT GARBAGE-BAG-OUTFIT MAZE!

Put your pencil down, flip it, and reverse it to find your way through this garbage-bag-dress-inspired maze! Just make sure you're ahead of the game!

FUN FACT: Missy Elliott once wrote Michael and Janet Jackson a letter claiming to be terminally ill in order to get their attention.

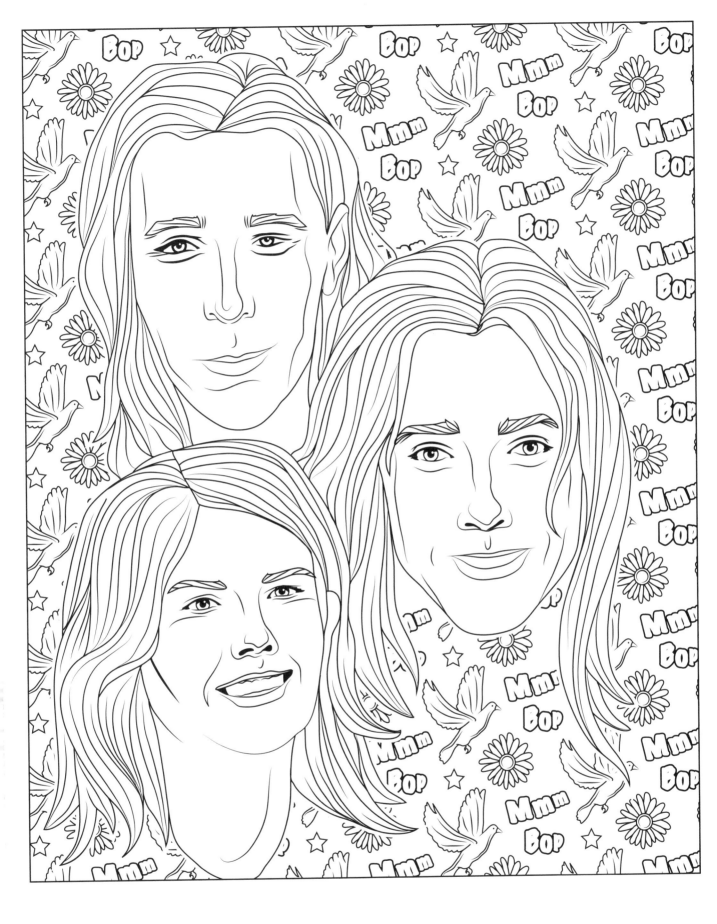

HANSON

HANSON TWO TRUTHS & A LIE!

Hanson thinks you should hold on to the ones who really care. Hanson thinks that in the end, they'll be the only ones there. Hanson thinks dogs have the power of speech but are just hiding it. One of those is a lie! Choose the lie out of the sets of fun facts below and discover which are true at the bottom of the page.

ROUND 1 — WHICH IS A LIE?

A. In biblical music–video series *Yo Kids!: The Vidz*, Taylor Hanson played a young King David facing off with Goliath.

B. In biblical music–video series *Yo Kids!: The Vidz*, Isaac Hanson played a sports commentator.

C. In biblical music–video series *Yo Kids!: The Vidz*, Zac Hanson played a referee.

ROUND 2 — WHICH IS A LIE?

A. On February 1, 1998, Hanson reached number 1 on the New York Times Best Seller list.

B. On January 24, 2007, Hanson officially broke up.

C. May 6 is Hanson Day in Tulsa.

ROUND 3 — WHICH IS A LIE?

A. Hanson cowrote a Switchfoot song.

B. Hanson sang in an Owl City song.

C. Hanson appeared in a Katy Perry music video.

ROUND 4 — WHICH IS A LIE?

A. Taylor Hanson has been a judge on *Cupcake Wars*.

B. Taylor Hanson has been a guest on *TRL Italy*.

C. Taylor Hanson has been a presenter at the Emmys.

ANSWERS: 1. C is a lie. **2.** B is a lie. **3.** A is a lie. **4.** C is a lie.

RICKY MARTIN

FUN FACT: Ricky Martin was on *General Hospital* for one season.

RICKY MARTIN
WHICH THING IS NOT LIKE THE OTHER?

Search Ricky to find ten loco things in picture number 2 that don't match picture number 1!

FUN FACT: Ricky Martin recorded eleven albums with boy band Menudo between the ages of twelve and seventeen.

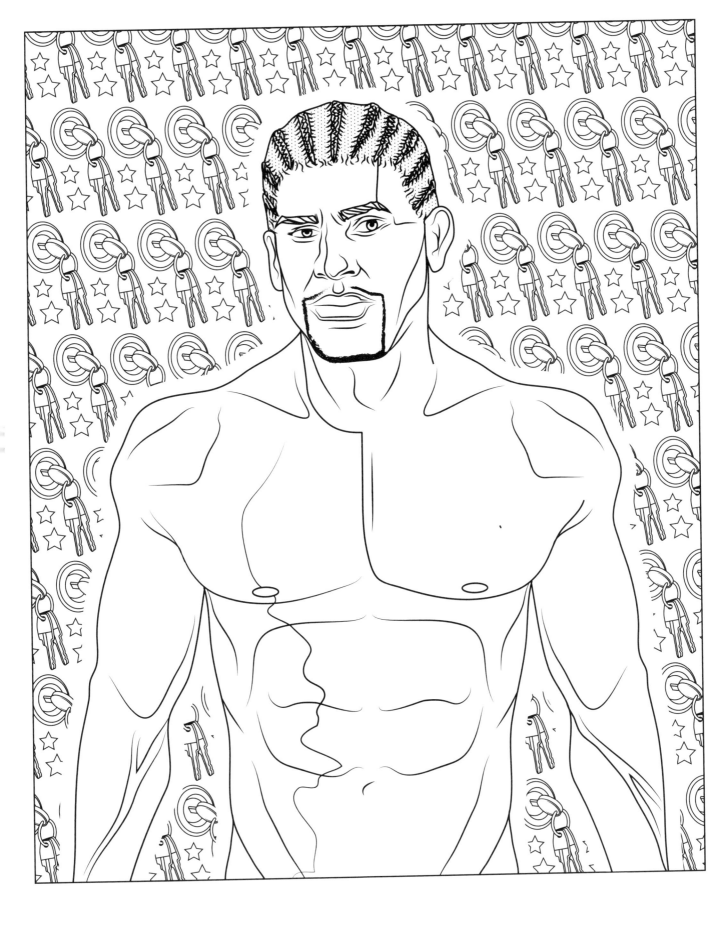

R. KELLY

R. KELLY THAT'S SO '90s POP QUIZ!

Do you believe you can fly? If you can see it, can you do it? If you answered yes to either of those, try your hand at these questions in the That's So '90s Pop Quiz below to find out how much you know about R. Kelly!

QUESTION 1

IN 1991, R. KELLY SIGNED WITH JIVE RECORDS AFTER EXECS HEARD HIM SING WHERE?

A. A live local radio performance.

B. A reality competition show.

C. A street performance in Chicago.

D. A mixtape he had mailed to their office.

QUESTION 2

R. KELLY WAS NOT JUST A MUSICIAN. HE ALSO WAS A PROFESSIONAL BASKETBALL PLAYER FROM 1997 TO 1999. WHAT TEAM DID R. KELLY PLAY FOR?

A. The Atlantic City Seagulls.

B. The Coney Island Cyclones.

C. The Delaware Stars.

D. The Empire State Stallions.

QUESTION 3

WHICH *AMERICAN IDOL* CONTESTANT HASN'T COVERED R. KELLY'S *SPACE JAM* THEME SONG, "I BELIEVE I CAN FLY"?

A. Katharine McPhee.

B. William Hung.

C. Ruben Studdard.

D. Aaron Kelly.

QUESTION 4

WHICH AWARD DID R. KELLY NOT WIN?

A. A Grammy.

B. An Emmy.

C. A Guinness world record.

D. An NAACP Image Award.

QUESTION 5

WHAT WAS THE ABBREVIATED NAME FOR R. KELLY'S SINGING GROUP IN THE EARLY '90s?

A. USA. **B.** MGM.

C. AKA. **D.** TNT.

ANSWERS: 1. B 2. A 3. C 4. B 5. B

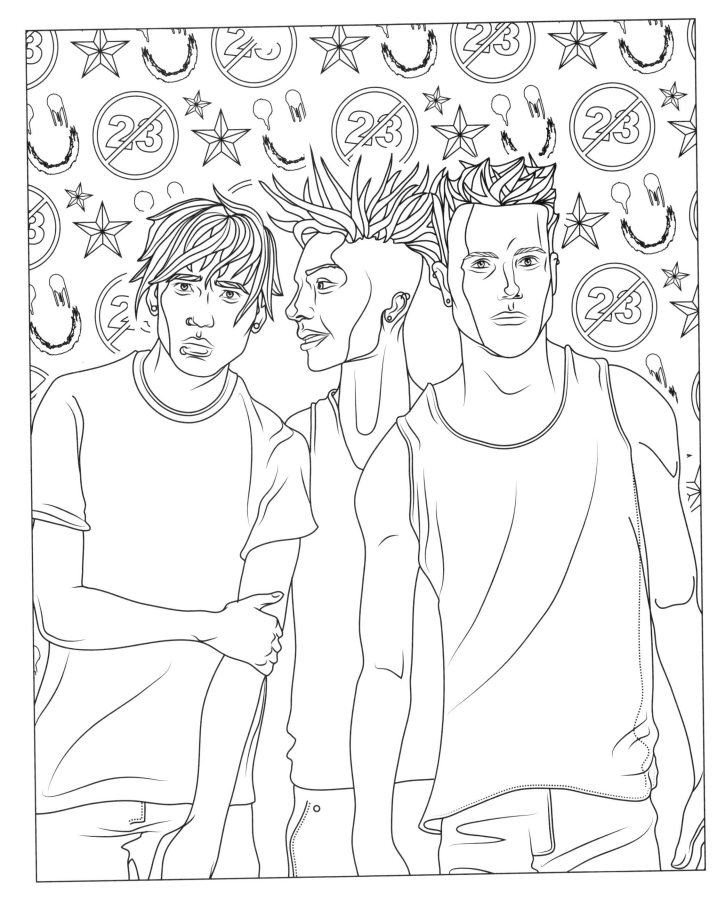

BLINK-182

FUN FACT: The riff of "Dammit" was created because two strings were missing from Hoppus's guitar.

BLINK-182 WORD SEARCH!

Work sucks so take a break and complete this puzzle! Find all the following words spelled forward, backward, upward, or downward in the word search below!

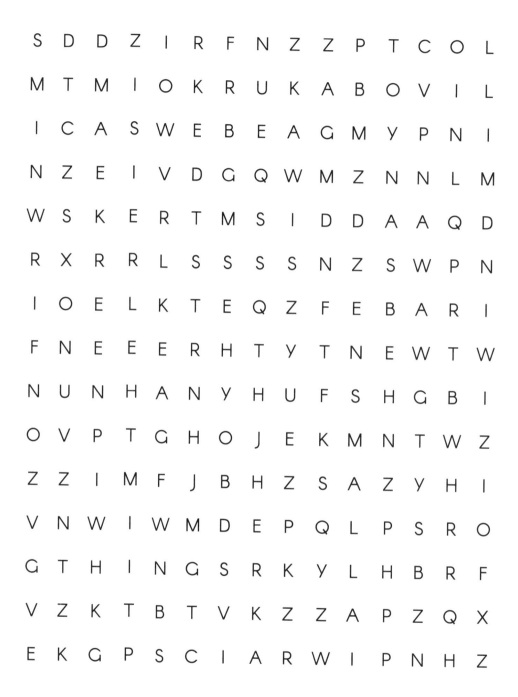

```
S  D  D  Z  I  R  F  N  Z  Z  P  T  C  O  L
M  T  M  I  O  K  R  U  K  A  B  O  V  I  L
I  C  A  S  W  E  B  E  A  G  M  Y  P  N  I
N  Z  E  I  V  D  G  Q  W  M  Z  N  N  L  M
W  S  K  E  R  T  M  S  I  D  D  A  A  Q  D
R  X  R  R  L  S  S  S  S  N  Z  S  W  P  N
I  O  E  L  K  T  E  Q  Z  F  E  B  A  R  I
F  N  E  E  R  H  T  Y  T  N  E  W  T  W
N  U  N  H  A  N  Y  H  U  F  S  H  G  B  I
O  V  P  T  G  H  O  J  E  K  M  N  T  W  Z
Z  Z  I  M  F  J  B  H  Z  S  A  Z  Y  H  I
V  N  W  I  W  M  D  E  P  Q  L  P  S  R  O
G  T  H  I  N  G  S  R  K  Y  L  H  B  R  F
V  Z  K  T  B  T  V  K  Z  Z  A  P  Z  Q  X
E  K  G  P  S  C  I  A  R  W  I  P  N  H  Z
```

FIND: FOREVER, SMALL, THINGS, ROSES, STAIRS, ADD, TWENTY-THREE, PAY PHONE, COMMISERATING, WINDMILL

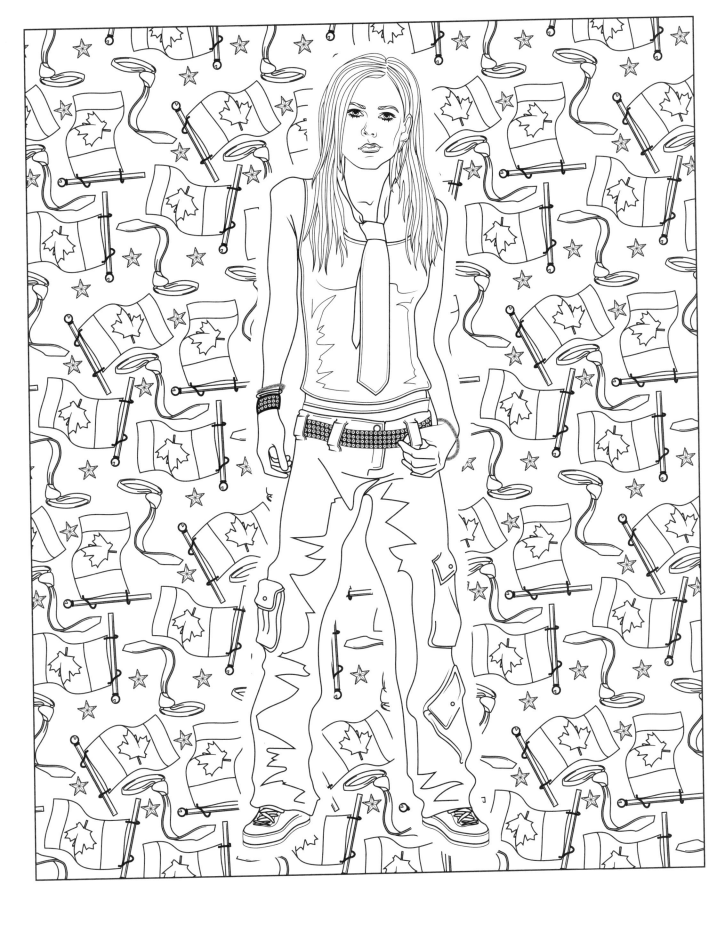

AVRIL LAVIGNE

AVRIL LAVIGNE POP PUNK POP QUIZ!

He was a **A.** Gator Boy! **B.** Sk8er Boi! **C.** Traitor Boy! or **D.** Crater Boy! Did you guess **B**? If yes, then you'll ace this Pop Punk Pop Quiz all about Avril Lavigne! Take the quiz below and discover the correct answers at the bottom of the page!

QUESTION 1

AVRIL LAVIGNE APPEARED ON STAGE AT THE AGE OF FIFTEEN WITH

A Shania Twain. **B** Gwen Stefani. **C** Cyndi Lauper. **D** Debbie Gibson.

QUESTION 2

AVRIL LAVIGNE HAS SOLD HOW MANY SINGLES WORLDWIDE?

A 30 million. **B** 40 million. **C** 50 million. **D** 60 million.

QUESTION 3

AVRIL LAVIGNE PLAYED WHICH CGI-ANIMATED CHARACTER?

A Hawk, an emperor penguin in the film *Happy Feet*.

B Ivory, the Mongolian wombat in the film *Kung Fu Panda 2*.

C Abby, a Canadian mallard in the film *Chicken Little*.

D Heather, a Virginia opossum in the film *Over the Hedge*.

QUESTION 4

AVRIL LAVIGNE COWROTE KELLY CLARKSON'S "BREAKAWAY" FOR WHAT ORIGINAL MOTION PICTURE SOUNDTRACK?

A *The Princess Diaries 2: Royal Engagement*. **B** *Confessions of a Teenage Drama Queen*.

C *13 Going on 30*. **D** *New York Minute*.

QUESTION 5

AVRIL LAVIGNE'S FIRST ACTING APPEARANCE ON TELEVISION WAS

A A 2002 episode of *Sabrina, the Teenage Witch*.

B A 2003 episode of *Nip/Tuck*.

C A 2004 episode of *Law & Order: Special Victims Unit*.

D A 2005 episode of *One Tree Hill*.

QUESTION 6

IN *THE FLOCK*, THE 2007 CRIME THRILLER STARRING RICHARD GERE AND CLAIRE DANES, AVRIL LAVIGNE PLAYED WHO?

A Jessica Jaymes, and adult-film actress.

B Beatrice Bell, the girlfriend of a suspected killer.

C Danielle Downs, an unhelpful bartender.

D Heather Henley, a sales clerk who witnesses the crime.

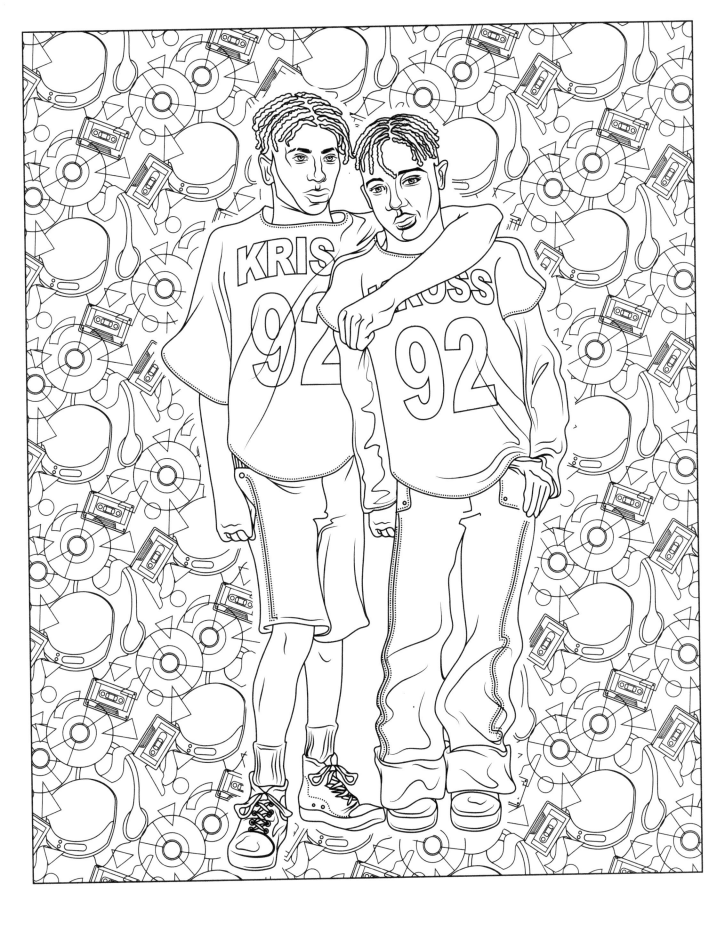

KRIS KROSS

↳ **FUN FACT:** Kris Kross became known for wearing their clothing backward.

KRIS KROSS KRIS CROSSWORD

Does Kris Kross make you wanna solve these following clues to complete the Kris Kross crossword puzzle below? Use a pencil in case you have to kris kross anything out!

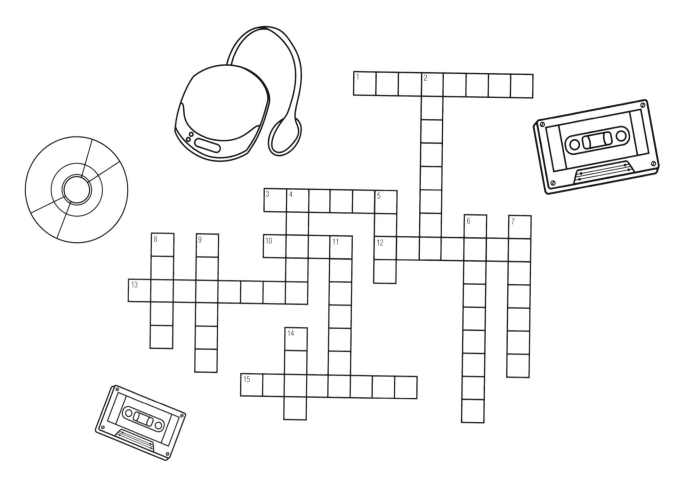

ACROSS

1. To revive a car battery, twice

3. Food's first impression

10. Career birthplace of Debbie Gibson, Britney Spears, Kris Kross, and more

12. Contrast's longtime partner

13. Embraceable

15. Begin

DOWN

2. One million sold

4. Depart

5. Surname of cartoon billionaire child

6. Inspires caution

7. To see, to some

8. Wasters of youth

9. Contort enthusiastically

11. Worthy of affection

14. Hind

FUN FACT: Kris Kross were discovered by Jermaine Dupri.

LOS DEL RÍO

FUN FACT: "Macarena" was the longest-running #1 and bestselling debut single of all time in American music history.

LOS DEL RÍO TWO TRANSLATIONS & A LIE

Give your body joy, Macarena, and take this special Two Truths & A Lie quiz all about the English tranlsation of "Macarena!" Choose the lie out of the sets of fun facts about the true meaning behind "Macarena" below and discover which are true at the bottom of the page.

ROUND 1 — WHICH IS A LIE?

A. *Macarena* means "clever girl."

B. *Macarena* means "mother of God."

C. *Macarena* means "women."

ROUND 2 — WHICH IS A LIE?

A. The chorus of the song encourages Macarena to bring joy to her body.

B. The chorus of the song tells Macarena to be careful with her heart.

C. The chorus of the song tells Macarena her body is for giving happiness to others.

ROUND 3 — WHICH IS A LIE?

A. In the song, Macarena is cheating on her boyfriend with at least one man.

B. In the song, Macarena is cheating on her boyfriend with at least two men.

C. In the song, Macarena is cheating on her boyfriend with at least three men.

ROUND 4 — WHICH IS A LIE?

A. Macarena's boyfriend's last name is Vitorino.

B. While she's cheating on him, Macarena's boyfriend is joining the army.

C. Macarena's boyfriend is also cheating on her.

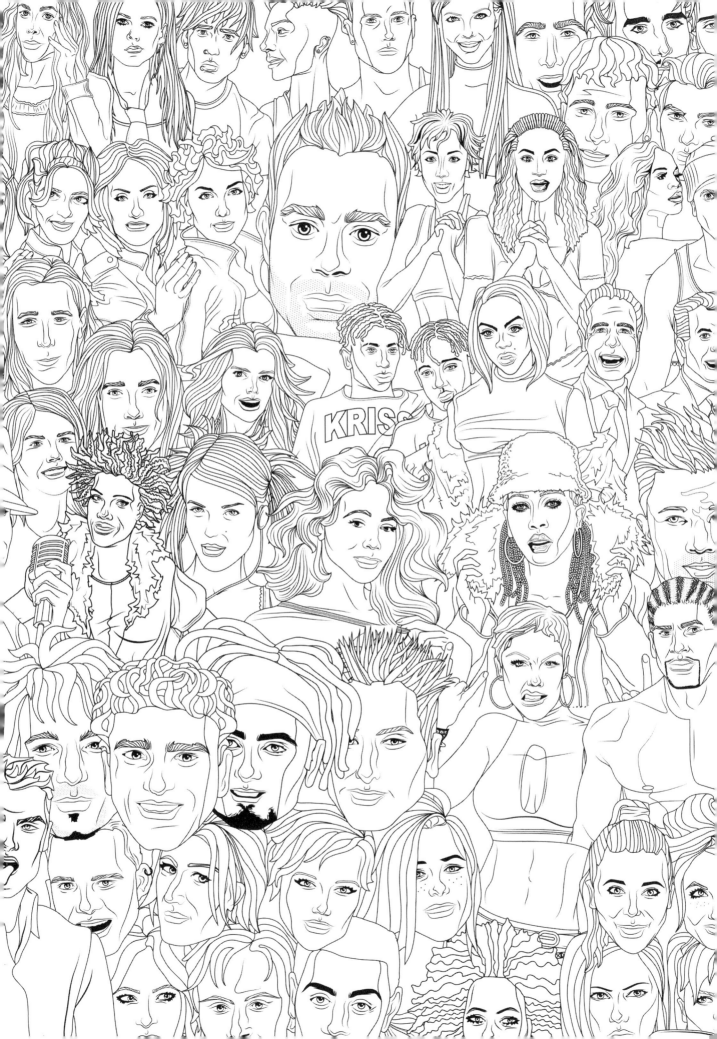